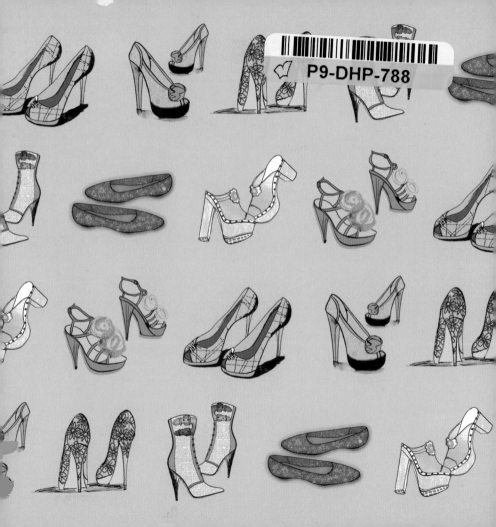

why girls love
SHOES

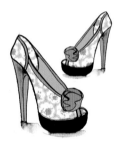

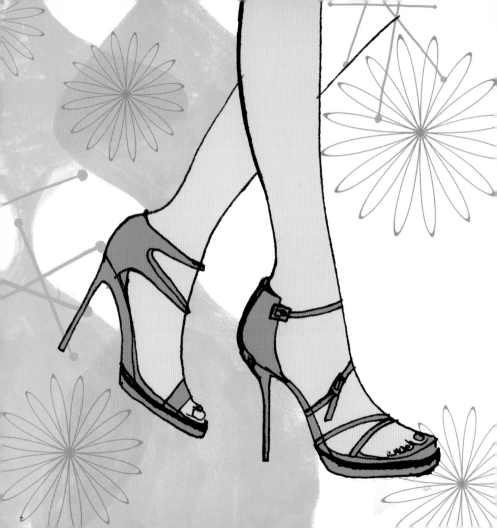

why girls love

SHOES

A celebration of a girl's best friend

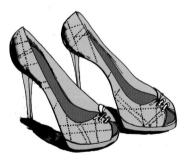

Illustrations by Sam Wilson & words by Georgina Harris

CICO BOOKS
LONDON NEW YORK

Published in 2010 by CICO Books
An imprint of Ryland Peters & Small
20–21 Jockey's Fields,
London WC1R 4BW
519 Broadway, 5th Floor,
New York, NY 10012
www.cicobooks.com

10 9 8 7 6 5 4 3 2 1

Text copyright © Georgina Harris 2010
Illustrations: Sam Wilson
Design: Paul Tilby
Design and illustration copyright
© CICO Books 2010

A CIP catalog record for this book is
available from the library of Congress
and the British Library.

ISBN 978 1 907030 74 1

Printed in China

contents

introduction: shoe appeal

Seemingly endless, and deliciously mysterious, our fascination with shoes might almost defy explanation. But what else—literally—lifts you and carries you through life? We make our life journeys in and with our favorite shoes; these flourishes of fashion stay with us through events big and small, good times and bad, parties and celebrations—so shoes, sandals, and lovely boots are perhaps not so frivolous after all.

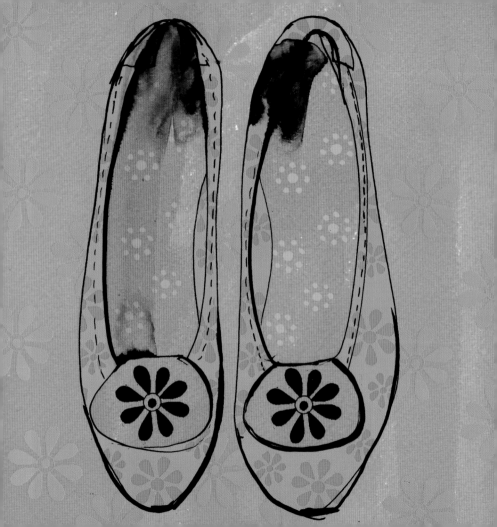

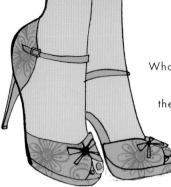

Who doesn't remember the shoes they wore for their first dance? Or the glossy pump that helped carry them through their first proper job interview? Who could be immune to the true alchemy that the perfect combination of ladylike leg and glittery sandal create to transform an unremarkable pair of jeans to a killer party outfit? As we all know, the right shoe on the right occasion makes every outfit fabulous.

a little shoe history

Shoes are important, and getting them right matters. Hot shoes even make history and literature—Hans Christian Andersen's *The Red Shoes* (1845) is

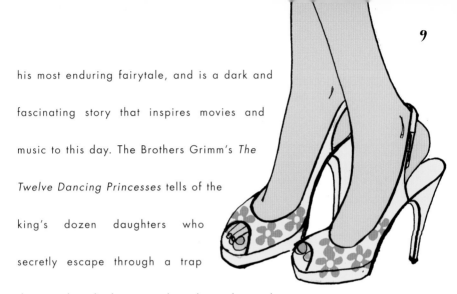

his most enduring fairytale, and is a dark and fascinating story that inspires movies and music to this day. The Brothers Grimm's *The Twelve Dancing Princesses* tells of the king's dozen daughters who secretly escape through a trap door in their bedroom each night to dance the night away with their princes. To their bewildered father, the only symbol of their exciting lives beyond the castle walls are twelve pairs of worn-out dancing slippers. As for Cinderella, this classic folk tale of a young girl released from drudgery to love and riches by a single slipper has variants

all over the world. It's thought that the first version was created in Ancient Greek culture. The King in the original version of the story was fascinated by the beautiful shape of an unknown maiden's sandal, and so he went on to search the breadth and depth of the country to find this girl and make her his wife.

In modern times, contemporary screen goddess Marilyn Monroe paid tribute to the inventor of the stiletto, allegedly wearing one heel shorter than the other to emphasise her legendary wiggle. The high heel, modern age's most

enduring icon of style, is now compulsory business wear in many

corporations, which sums up the power it creates.

shoe seduction

And as to its overwhelmingly strongest effect, that of seduction, every woman

alive looks hotter in heels. So whether you choose a

classic cigarette-heeled patent pump, a

magical red shoe, floral sandals, or a fierce

shoe-boot, you know your shoes will make

you look slimmer, stand tall, and face the

world better. What's not to love?

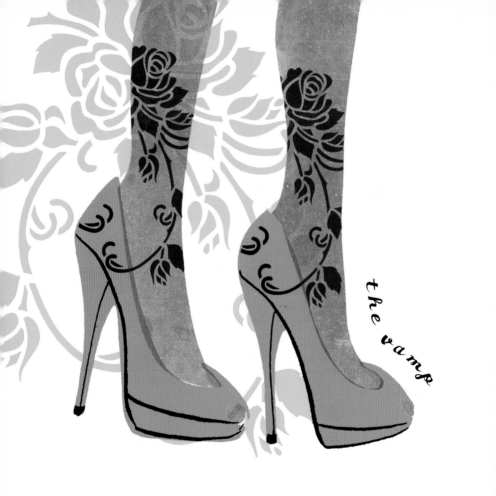

the vamp

killer heels

Sexiness can be defined in two words. High. Heels.

polka dotty

perfectly formal, discreet, and elegant as they dutifully appear, these polka-dot pretties illustrate a fundamental truth about a good high heel. While you are engaged in serious, frank, and straightforward chat, your shoes can suggest something entirely different—and a lot more fun.

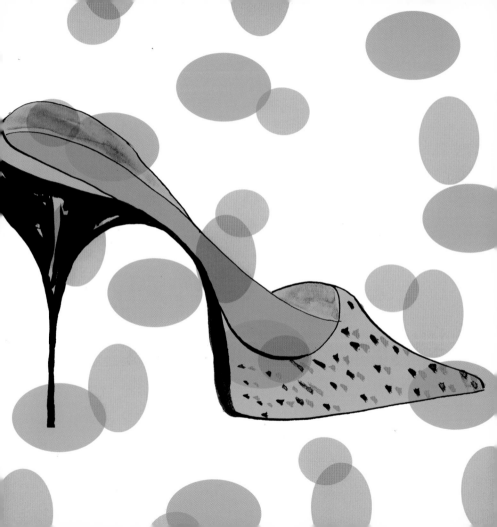

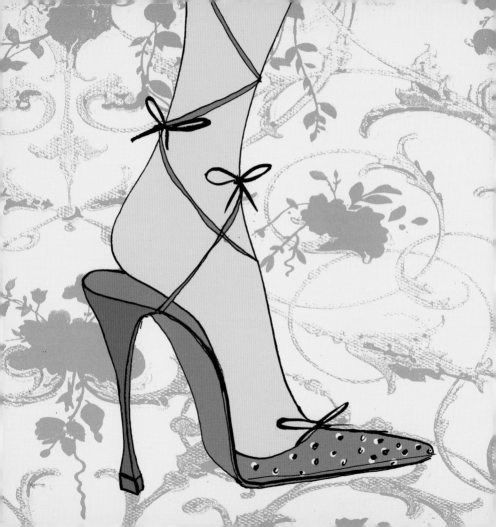

delicate heels

Fragile suede ties, tiny petal trims, and a heel so slim it looks as if it could snap in the wind—but there's a secret core of steel in there. Remind you of anyone?

extra~high heels

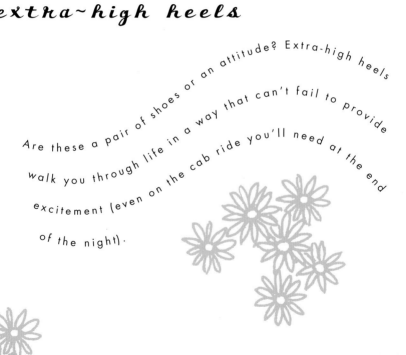

Are these a pair of shoes or an attitude? Extra-high heels walk you through life in a way that can't fail to provide excitement (even on the cab ride you'll need at the end of the night).

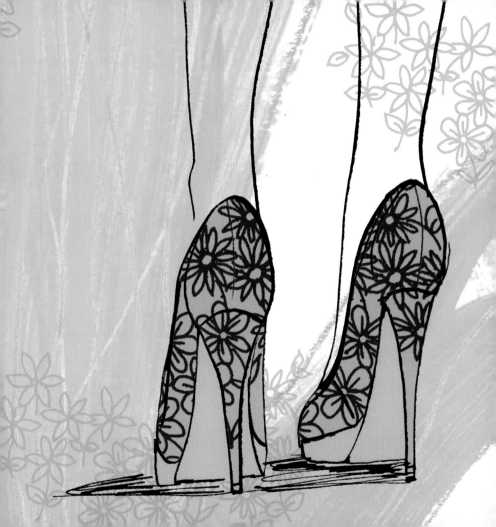

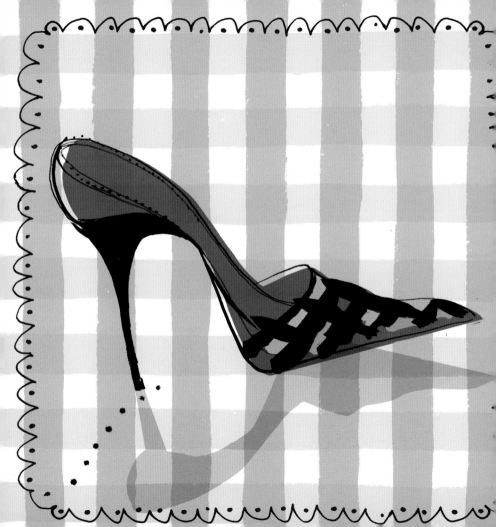

Moving, walking, dancing—shoes show the movement of our souls more than words can ever say.

high stiletto

You'd think a busy pattern, straps, and a tall

heel would be hard to dress—quite the opposite!

Whether you're matchy-matchy in the new neutrals or

wittily eclectic, you will find that snakeskin

and its jungle relations boost, not reduce, the rest of your outfit.

*snakeskin
heels*

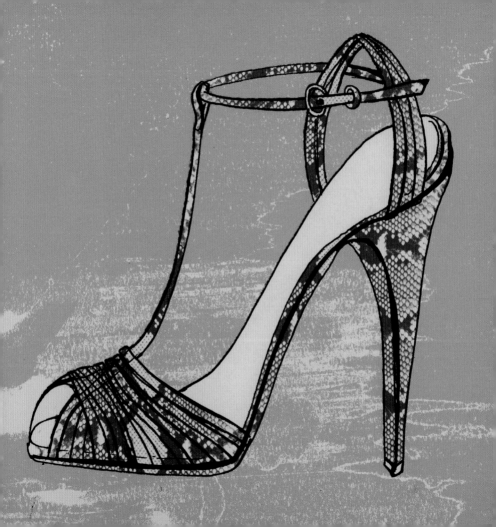

tutti frutti Platform peep-toes never date—quite right, too. Leg-lengthening, back-straightening, and gloriously comfortable, the only strong pressure they apply is not on the wearer, but the viewer.

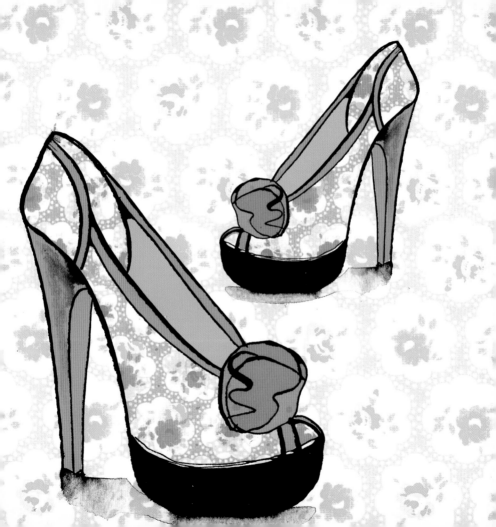

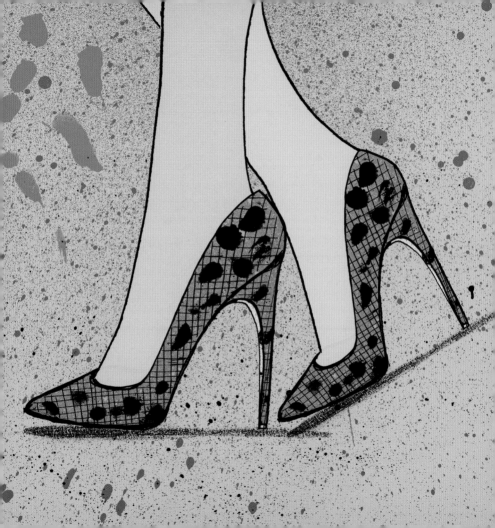

Animal-print pumps combine the restrained chic
of a classic shape with the lure of the wild. The
resulting tension is the essence of effective sex appeal -
and they look great with black or bare legs.

wild things

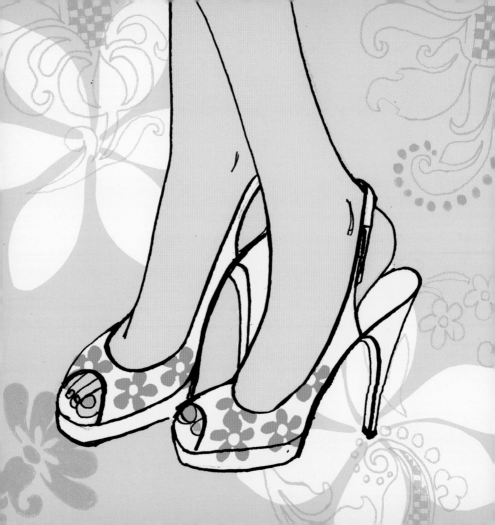

office angel

sandal stiletto

a shoe needs to keep you feeling a little fun and frivolous, A good shoemaker knows that whatever the workday brings.

Lift yourself up in the style stakes in seconds with a cigarette heel, and add a coyly pointed toe as the finishing touch.

ankle strap

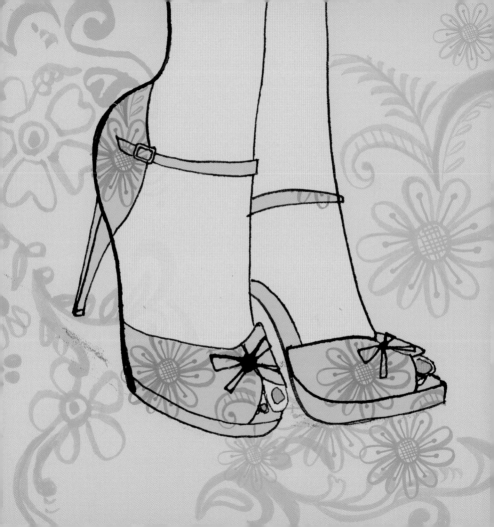

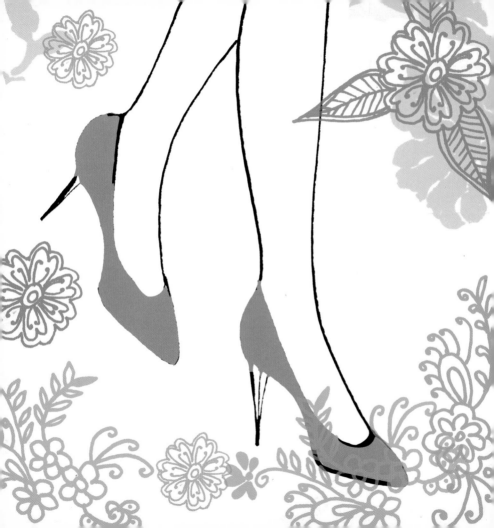

classic

The classic pump lifts the mood as well as the body; your legs look longer, your walk swings snappily, and you stand tall and proud. Most other things that have this effect are illegal, as it happens...

mock~croc heels

In a family letter, eighteenth-century novelist Jane Austen bequeathed us this salient style rule: "Dress is at all times a frivolous distinction, and excessive solicitude about it often destroys its own aim." She truly understood that less is more—and would have appreciated just how powerful the bite of understated mock-croc killer heels can be.

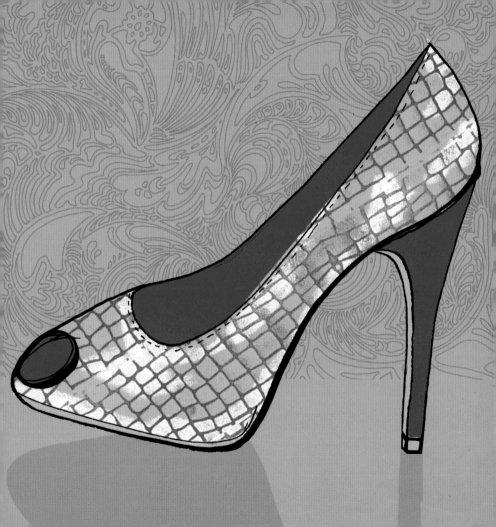

With a classic pump, the golden rule is: if the shoe fits, it's too expensive. So shoot us.

pump heels

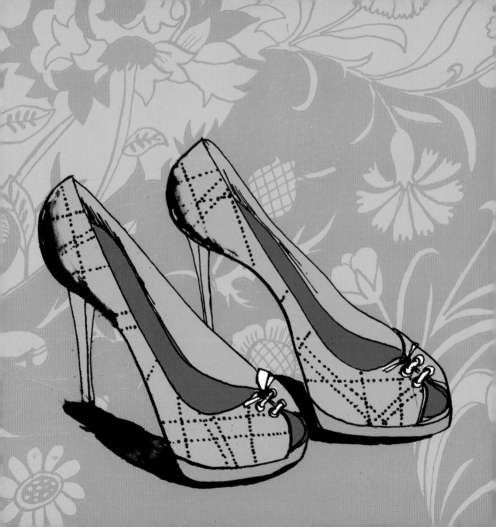

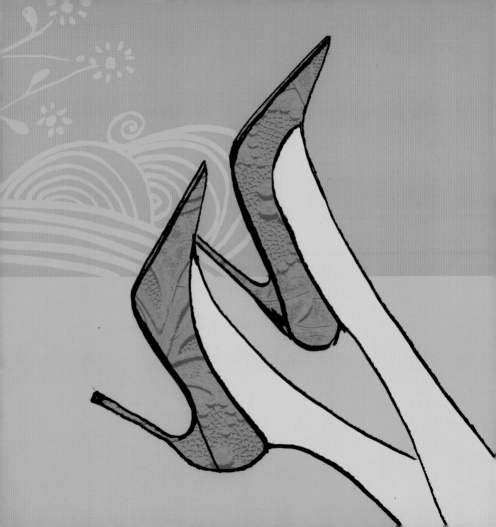

Imagine the scene: A moonlit strip of sand, bronzed legs, a floaty dress, and someone to take your arm. Razor heels may not technically count as beachwear, but there's more fun to be had in a bright pump than a flip-flop can provide. And think of the effect when you slip them off....

tahiti

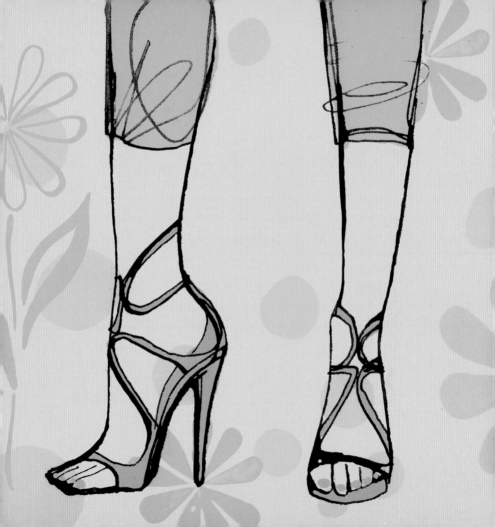

very strappy

Why settle for looking stylish when you have the world of art at your feet? Intricate straps, skyscraper heels, and glossy patents are nothing short of instant transformation—highlighting the true work of art, which is, of course, you.

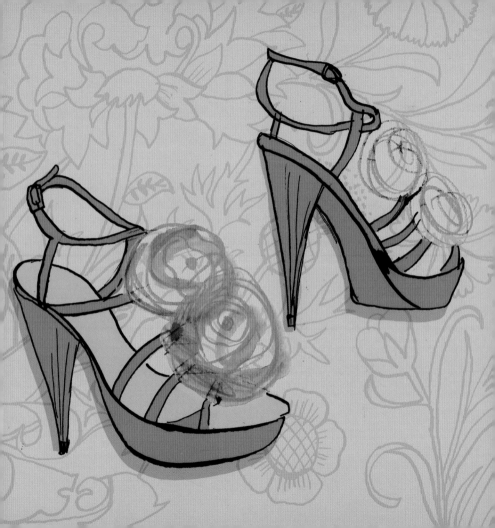

salsa shoes Scarlet, sassy, and made to move—what's not to love? The perfect party shoe makes your heart dance before your feet do.

ballroom blitz

The native American Hopi tribe had a saying: "To watch us dance is to hear our hearts speak." What more encouragement could a girl need to slip on her favorite flower-trimmed sandals?

the slingback

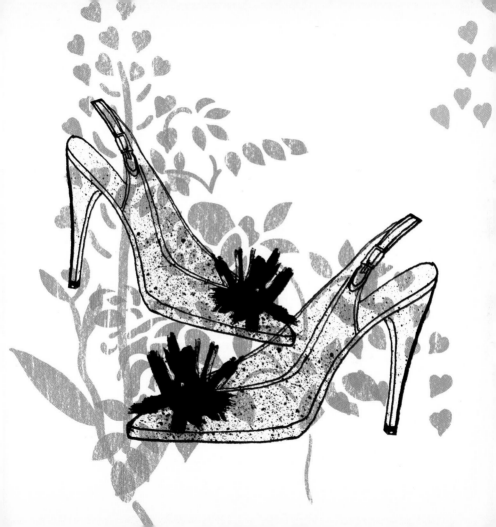

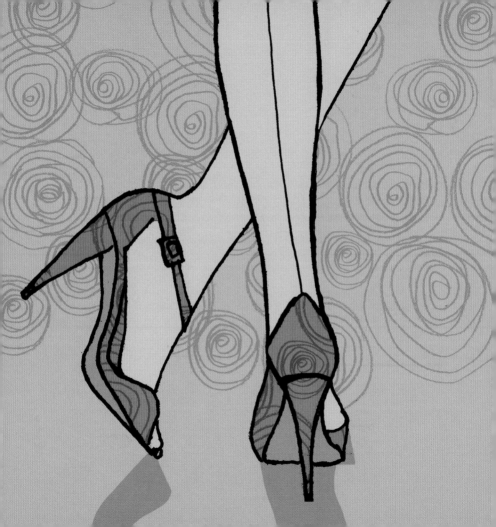

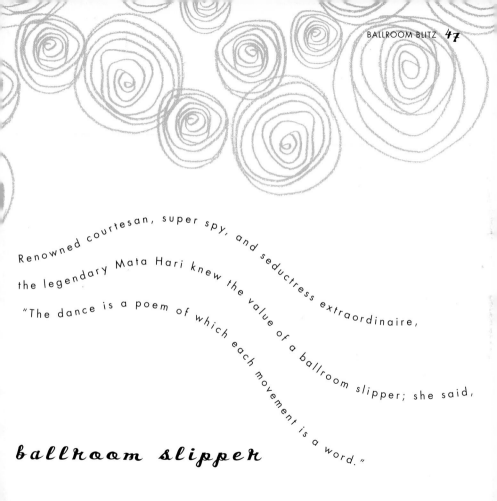

Renowned courtesan, super spy, and seductress extraordinaire, the legendary Mata Hari knew the value of a ballroom slipper; she said, "The dance is a poem of which each movement is a word."

ballroom slipper

glittery flats

Flats? Dull? Even divas need downtime. Glittery

go-tos match blissful comfort with the knowledge you are

channeling style icons such as Audrey Hepburn, Jackie O,

and Grace Kelly. Not bad work

for a walk to the store.

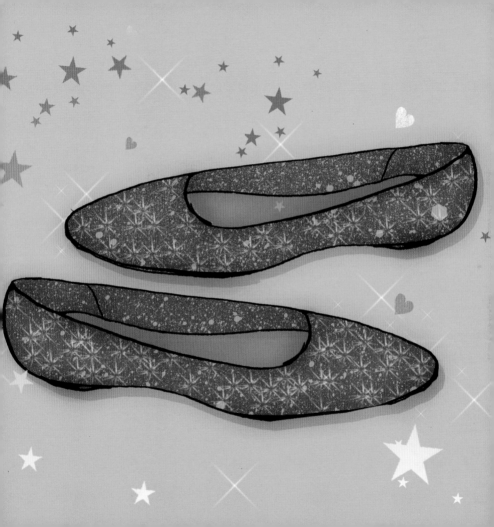

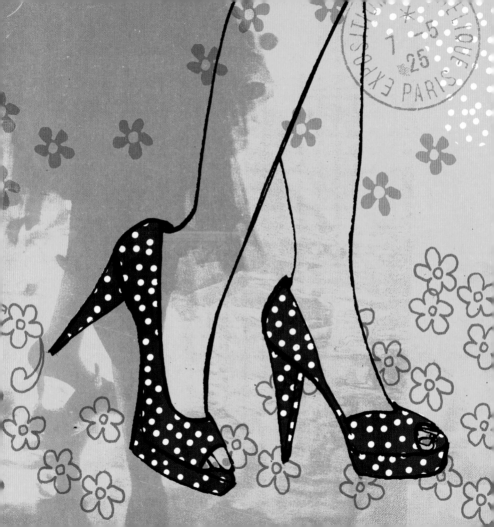

parisienne

Just sometimes, you want your shoes to be so high, so slim-fitting, and so precarious that it's your companion who can hardly breathe.

retro heels

Party shoes have been sources of fascination for centuries. In the seventeenth century, the very proper English poet John Dryden (1631–1700) was moved to remark: "Dancing is the poetry of the foot." From satin slippers to Studio 51 sandals, smart modern girls can take their pick of retro styles to make the most of this age-old allure.

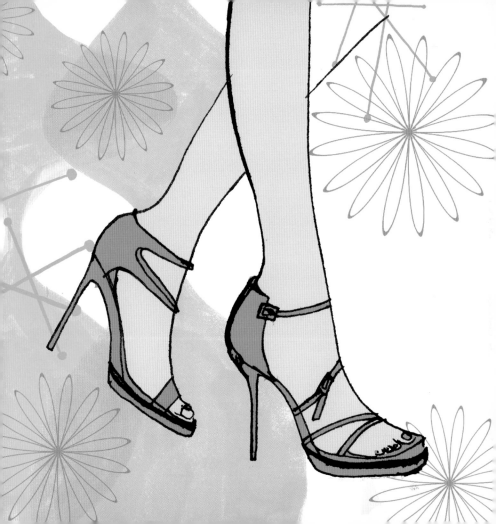

Walk to happiness—ruffles, ties, and

a touch of textured pattern can't fail

to lift the spirits, even if a good boot

remains stubbornly—and "can't-live-without"

—practical, too.

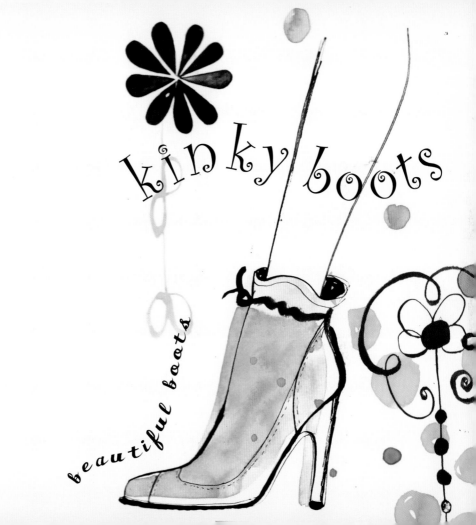

kinky boots

beautiful boots

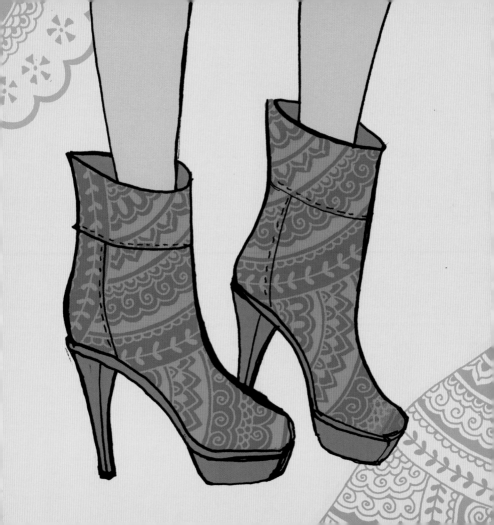

funky patterned

boots

Reboot required: sometimes a touch of new footwear
to tackle winter gloom is all that's needed
to refresh mind and body.

kinky boots should be properly improper. So cool it hurts (him, not you). With their ruthless chic straps, heels, lacing, and zips,

kinky boots

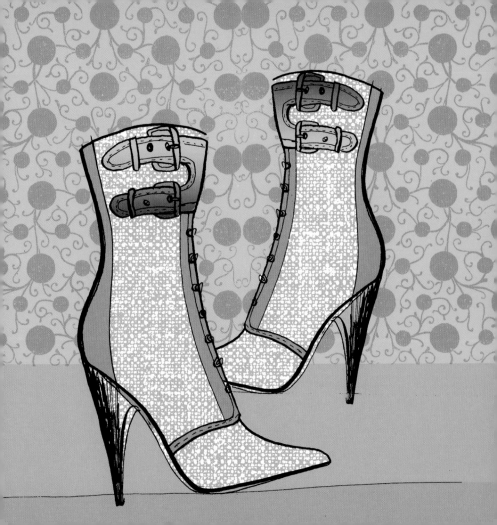

fashion~forward

The truly successful dresser understands that lure of the new just can't be resisted—a crazy seasonal pair of shoes is sometimes all you need for a full wardrobe update. They may look frivolous, but these little numbers make fine fashion economics.

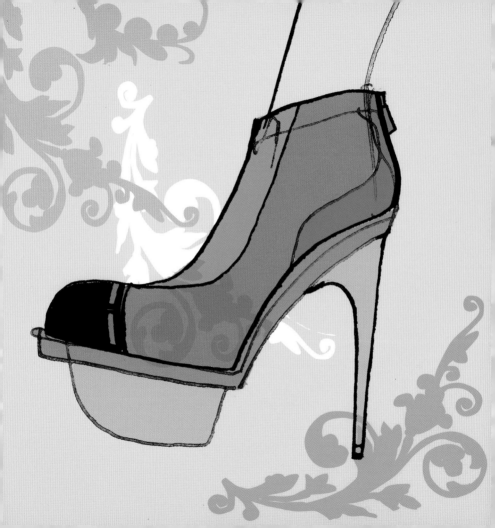

Marilyn Monroe

I don't know who invented the high heel, but all men owe him a lot.

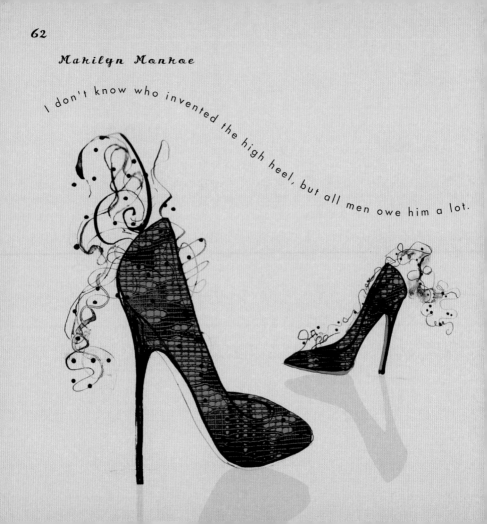

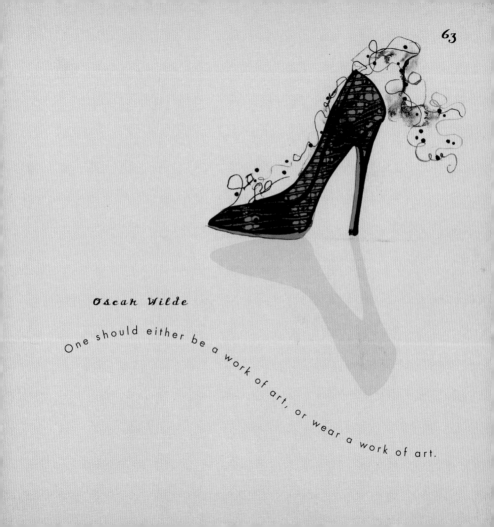

Oscar Wilde

One should either be a work of art, or wear a work of art.

Georgina Harris is an author and journalist on matters of life and style. She has written for *The Times* and the *Daily Telegraph* and has appeared on the BBC. She lives in Clapham Common, London, with her partner Steve, a fat tabby, and 104 pairs of shoes.

Sam Wilson studied visual art at Cheltenham, England, receiving a first class BA Honours degree, then went on to gain an MA in illustration in 1999. Sam began her professional career with commissions for *Tatler* magazine and soon began illustrating regularly for many other fashion titles including *Glamour*, *Red*, and *Elle Girl*. She illustrates a weekly column, "Fashion for Life," in the *Mail on Sunday's* "You" magazine. Sam also works in publishing, and has created artwork for many chick lit and lifestyle books, working with authors such as India Knight, Rita Konig, and Jenny Colgan.

In 2004 Sam was invited by leading fashion designers J&M Davidson to hold an exhibition in their London Gallery. Since the success of this show Sam now sells her originals and limited edition prints worldwide.

Sam's illustrations have been produced as window displays, in-store posters, and as packaging for retailers such as Harrods, Mulberry, Coast, Nougat, and Clarks Shoes.

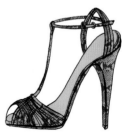

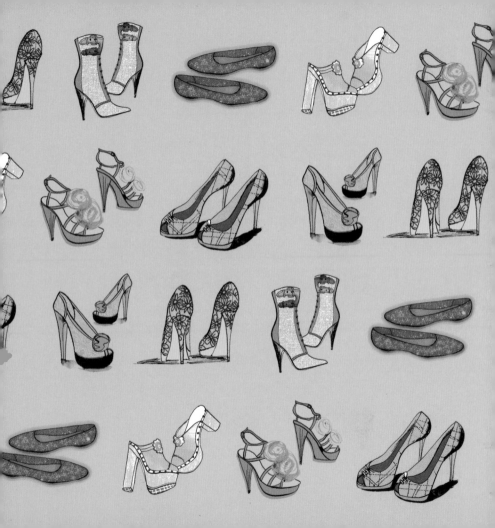